Let's Look for Farming in Illinois Post Offices

by

Mary Emma Thompson, Ph.D.
Photographs by Mary Emma Thompson, Ph.D.

Published by Mary Emma Thompson, Ph.D.
in Westfield, Illinois in 2008

ISBN 978-0-9770286-5-8

Introduction

Let's look in post offices to learn about farming. But you say to farm you have to be out in big fields with big equipment. That's common today, but it wasn't always so. Indians and early pioneers farmed to raise food for their families. With very little farming equipment and no easy way of transporting their excess products to other places, they worked hard just to feed their families. As new machinery was invented, farming became easier. Transportation improvements, such as trains crossing the nation, made it possible to ship produce to other places. Farmers began growing more than they could use so people in other places could benefit from the excess crops and animals raised by the farmers.

Farming is celebrated and recognized in artwork found in United States post offices. The art in post offices in Illinois and across the country was commissioned by the Treasury Department Section of Painting and Sculpture, which became the Section of Fine Arts. It was one of four federal art projects that put artists to work during the Great Depression of the 1930s and early 1940s.

Now let's look for the art showing farming in the post offices in Illinois.

First we will go to Peoria, which is north of Springfield on I-74 and I-155. The Federal Courthouse and Post Office has four limestone reliefs on the facade, which is the front of the building. A relief extends out from a flat surface. The one depicted here is an Indian standing in front of corn. Early Indians, like other early people, hunted animals, fished, and gathered fruit, nuts, berries, and grain to eat. No one knows when the Indians started farming, but they do know it was thousands of years ago. Once they began farming, they settled in small villages and were able to develop other skills, such as pottery making. Among the crops they grew were corn, squash, beans, and pumpkins with corn being a major crop. The Indians considered corn as a source of life. The Iroquois worshipped corn as one of the Three Sisters, which were corn, beans, and squash. Indians who farmed included corn in all their ceremonies.

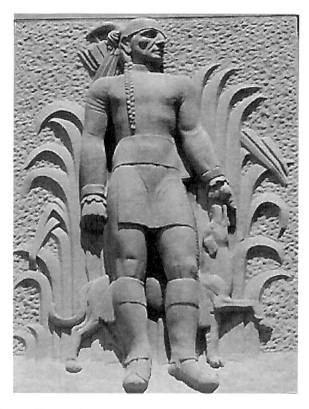

"Agriculture," Artist: Freeman Schoolcraft, Date: 1939,
Commission: $4585 for four reliefs
Post Office: Peoria

3

Our next stop is east of Springfield on U.S. Route 36 at Decatur, where we visit the post office on North Franklin Street. In the south lobby of the post office, we find a mural of Indians raising corn. The original sketch showed Indians hunting. As you look at the picture, you will see a brave kneeling by the corn, but that was not typical of Indian life. The braves did the hunting, while the women did the farming and the work around the village. Men who could no longer go hunting may have helped with the farming.

When the Indians harvested the corn, they shelled it and stored it in jars or sometimes stored it on the ears. Then it was ground with stones to make cornmeal. From the cornmeal they made bread or mush to feed their families. If they had extra corn, they might trade it for things they needed. Indians often provided corn to explorers, who in turn gave them trinkets from Europe. The Indians taught the first European settlers how to raise corn and how to use it for food for their families and their animals.

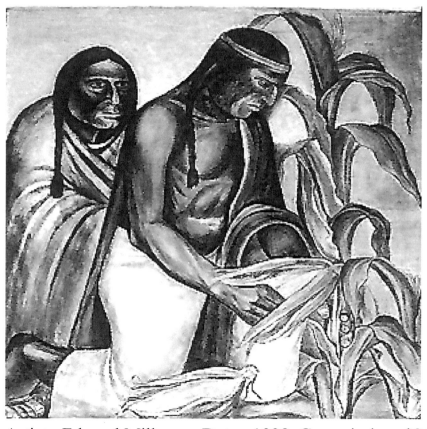

"Early Pioneers," Artist: Edward Millman, Date: 1938, Commission: $2400 for six murals
Post Office: Decatur

5

While in Decatur, we will look at another mural in the south lobby of the post office. Here we see a man and his son at a land grant office, where they could get land to farm. To encourage pioneers to move to the area, the United States government gave them land. They had to build a cabin and farm the land for one or more years before it became theirs, but it didn't cost them any money. For example, the Homestead Act of 1862 stated that they could own the land in five years if they lived on it and made improvements to it. Sometimes pioneers had to travel many miles to get to the land grant office to register for the land they wanted. People in the Decatur area had to travel to Vandalia to get their land. With no roads or very poor ones, it took days to travel by horse or on foot that far. It was even worse during rainy weather, because they traveled through mud or in winter when the snow was deep.

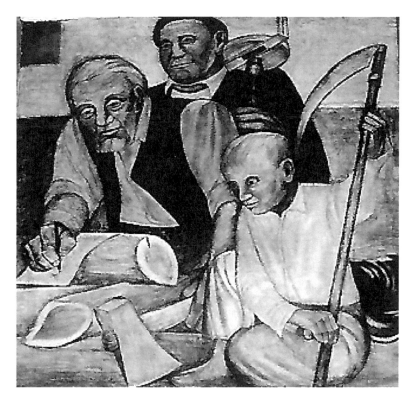

"Early Pioneers," Artist: Edward Millman, Date: 1938, Commission: $2400 for Six Murals
Post Office: Decatur

While in the Decatur Post Office's center lobby, we will also see one of the murals by Mitchell Siporin. The first mural shows a pioneer family living in their covered wagon. They are building a log cabin, but when farming season neared, they had to get ready for that. Much of the land was prairie with tall grass growing on it. Trees grew along the rivers and streams. The pioneers could not plow the prairie with their wooden plows, so they cut down the trees and farmed around the stumps. It was hard work to plow the ground, plant it, and care for crops as they grew. After John Deere invented the steel plow, they could plow the prairie, but it was still hard work. Sometimes the crops didn't produce much. Farmers also had to grow their own vegetables. They had a cow to give them milk and maybe some pigs and chickens. They raised most of the food they would eat for the next year. There weren't any stores where they could buy groceries like we have today. Besides they had very little money to spend, so pioneer families did what we call subsistence farming, which means they worked to raise enough to feed their families and their animals. If they didn't, they might go hungry. Would you like to live like the early settlers lived?

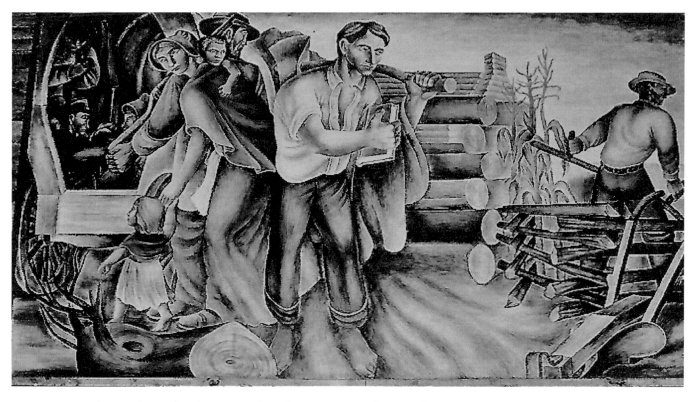

"Fusion of Agriculture and Industry," Artist: Mitchell Siporin, Date: 1938,
Commission: $2250 for three murals
Post office: Decatur

Now let's go northwest of Decatur to Carthage, which is on U.S. Route 136 and Illinois State Route 94. Here we see pioneer families farming and building a log house. It is likely that they traveled together to settle here. These families apparently arrived in the spring and lived in their wagons until their crops were planted. Then they worked together to build their log cabins and barns. When the crops were ready to be harvested, some of the men and women gathered in the crops, while others continued to work on the buildings. Would you like to harvest the crops or to help build the cabin? The man on the right has a gun. Hunting was important as a way to provide meat for the family.

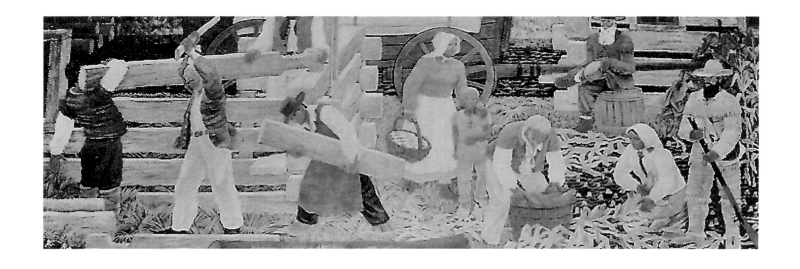

"Pioneers Tilling Ground and Building Cabin," Artist: Karl Kelpe, Date: 1939,
Commission: $470
Post Office: Carthage

11

Next we will visit Virden, which is south of Springfield on Illinois State Route 4. This mural is titled "Illinois Pastoral." I always think of pastoral as being quiet and peaceful. The artist, James Daugherty, shows as much of farm life as he possibly can in this mural. On the left we see a woman milking a cow while a man, probably her husband, looks over the cow. On the ground are two children. It looks like the girl is holding an ear of corn to feed to the hog, while the boy is getting an apple from the man with the axe. In the background is a creek and some corn. A woman has taken her child to the field to see his father who is plowing with a walking plow. The plow was pulled by a horse, ox or mule while the man held it steady so it would plow the ground. Next it looks like a hunter is talking to a young lady. A woman is spinning yarn to weave into cloth which she will make into clothing for the family.

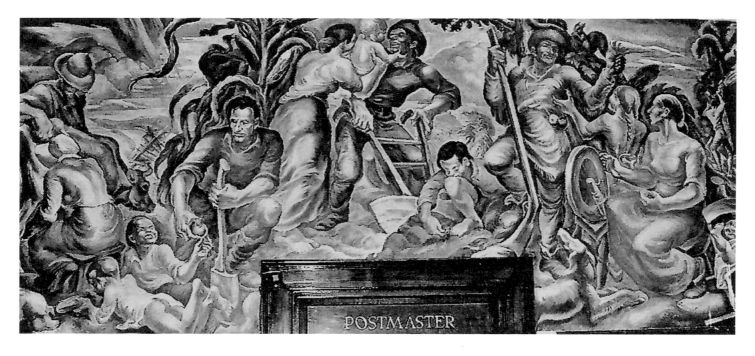

"Illinois Pastoral," Artist: James Daugherty, Date: 1939, Commission: $700
Post Office: Virden

Let's visit Oak Park, which is a suburb west of Chicago on I-290. One mural in the post office shows the train, the Pioneer, which went west from Chicago to Oak Ridge (Oak Park). The railroad was built in 1848 and was ten miles long. Many short railroads were built to carry farm produce into the city as a way to show the value of trains and to earn money to pay for extending them. The mural shows the stockholders' trip to inspect the train and a farmer carrying a bushel of wheat, which was the first grain transported by rail into Chicago. The first families that settled in Oak Park raised wheat. Before the railroad was built, they had to haul their grain into Chicago by horse and wagon.

The other mural shows the Osceola, which carried the first shipment of the farmers' crops from Chicago to another city in the early 1850s. The men are loading sacks of grain onto the train, possibly to be sent to Detroit since a railroad had been built from Detroit to Chicago.

"The Pioneer of 1848" "The Osceola,"
Artist: J. Theodore Johnson, Date: 1939, Commission: $3000, for four murals
Post Office: Oak Park

15

From Oak Park, let's go south to Tuscola. This town is on I-57 and U.S. Route 36. In this post office we see an early farm family bringing produce from their farm to ship by train to a nearby town. They made arrangements with a merchant, maybe in Arcola or Mattoon, to sell him the produce. The merchant then sent the farmer payment for it. Sometimes families rode the train to town to sell their produce and buy things they needed. Money was not very plentiful, so much of the time farmers traded their produce in town for things they needed. If he took corn to the mill to be ground, the farmer paid the miller with some of the meal, which the miller then sold or traded to someone else for other kinds of food, cloth, or tools that he needed. Trains at that time carried passengers and produce and stopped at every community along their routes. Passengers could ride a train to a nearby town in the morning and return by train later in the day.

Chickens were a common sight in yards and streets. Nearly everyone, even in town, raised chickens. The little chicks behind the wagon were hatched by a hen sitting on the eggs to keep the eggs warm.

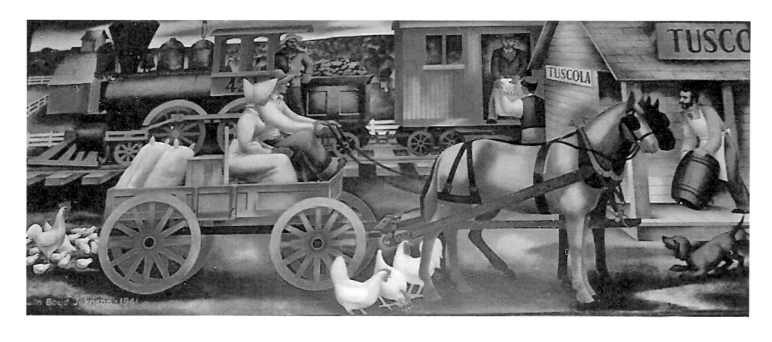

"The Old Days," Artist: Edwin B. Johnson, Date: 1941, Commission: $800
Post Office: Tuscola

Now we will go to Shelbyville by driving south from Tuscola to Illinois State Route 16 and driving west. The mural in this post office, "Shelby County Fair 1900," depicts one of the important annual events of farmlife. During the summer each county had, and still has, a county fair. Farmers took livestock to show and hoped to take home blue ribbons. Here we see different kinds of horses used in farming. Most farmers were very proud of their horses and took good care of them. On the far right, a blacksmith is making new horseshoes to fit the hooves of the horse. A village near Shelbyville named Prairie Home at one time had an African American blacksmith. They also took cows, sheep and pigs to the fair to show.

One of the highlights of a county fair was horse racing on the oval track. On the mural, look past the horses to part of the racetrack that can still be seen in the local park. The tall building was where the officials of the race watched the race to decide who won.

Women brought vegetables from their gardens, foods they had prepared, and items they had sewed, knitted, or crocheted to be judged. There were also carnival rides for children.

In the background you can see the top of the Chautauqua building, where educational and inspirational meetings were held during the summer.

Look at how strong the horses and the men appear to be. Farming was hard work for the animals and the men.

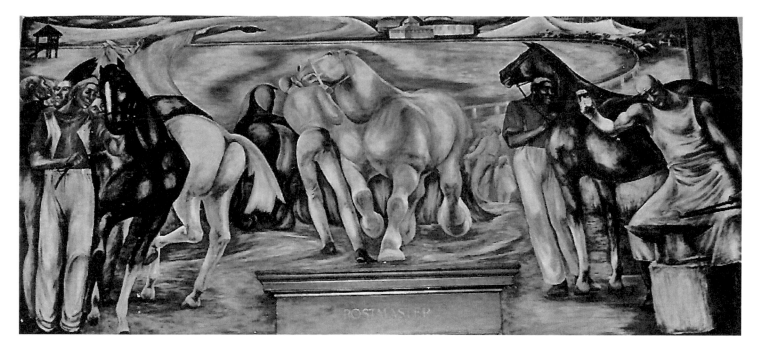

"Shelby County Fair, 1900" Artist: Lucia Wiley, Date: 1941, Commmission: $1000
Post office: Shelbyville

Let's travel northwest to Rock Falls on I-88 and Illinois State Route 40. Rock Falls has two reliefs made of plaster in its post office.

One relief depicts a woman with a rake and some sheaves of grain that she has raked together, showing early farming practices. In the distance behind her is a barn with a silo. The other relief shows a man standing in front of a machine. We can see the wheels. As new machines were invented, farming became easier, and farmers could raise more crops for sale.

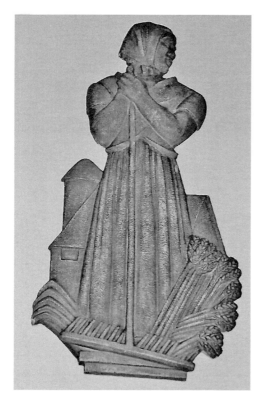 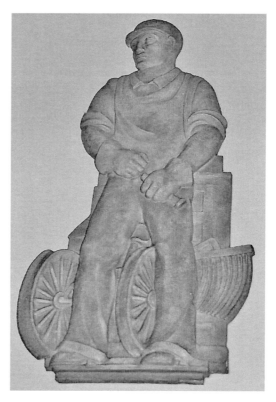

"Farming by Hand" and "Manufacture of Farm Implements,"
Artist: Curt Drewes, Date: 1939, Commission: $840
Post Office: Rock Falls

21

Next we go east to Kankakee on I-57, US Route 45 and Illinois State Routes 17, 113, and 102. The Kankakee Post Office has three wood reliefs that show the bounty of the farm. The woman has a sheaf of grain, probably wheat, although farmers also grew oats, barley and rye. In the center are farm animals. Hogs were an important source of meat. They were butchered in the winter when it was cold. Farmers usually butchered one or two at a time. Neighbors usually helped one another during butchering. The hogs were killed and dipped in scalding hot water so the hair could be scraped off. Then they were hung up and split down the underside to take out the insides. After the meat was cut up and cooled, it was cured by rubbing it with salt or salt and sugar, or smoking it so it would keep. They had ham, bacon, and tenderloin to eat during the winter. Much of the fat was cut off before the meat was cured. This was cooked to make lard for cooking. Everyone liked to eat the cracklings that were left after squeezing the lard out. Scraps of meat were ground and seasoned to make sausage. Some of it was usually made into patties that were fried and stored in the fat that was left from the cooking. They didn't have refrigerators or freezers to keep food fresh as we do today. Mincemeat was made by cooking some of the scraps of meat and adding fruit, sugar and spices to it. Mincemeat made good pies.

Turkeys were another source of meat, while chickens provided both eggs and meat. On the right is a man with a basket of corn. Unlike today's farm practices, most of the grain that farmers grew in the early days was used to feed the family and the livestock. Farmers also saved enough grain to use as seed to plant crops the next spring.

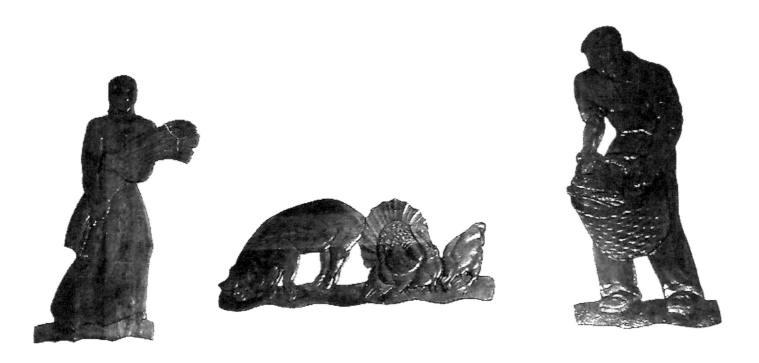

"Farming," Artist: Edouard Chassaing, Date: 1943, Commission: Unknown
Post Office: Kankakee

Now we go back to northwestern Illinois to Mount Carroll, which is on Illinois State Routes 64, 78 and 40. Mount Carroll is in the Wakarusa Valley, part of the Mississippi Valley country. The mural in the Mount Carroll Post Office shows several aspects of farmlife. The haystack was a common way of storing hay for the cows and horses. The man sitting on the ground is chewing on a grass stem or a piece of hay. The cat seems to be watching him. Cats were not usually in the house except maybe to catch mice. They usually lived in the barn and were given milk. Sometimes the person milking the cow would train the cat to drink the milk that was squirted at it. Cats were important because they lived primarily on mice. The woman is milking one cow, while her husband has already finished milking the other one. We see a horse, which was the source of power for farming for pulling the plow, disk, harrow, planter, cultivator, and at harvest time, the wagon to haul the grain.

Children also helped with the chores. Here we see a little girl helping her parents by feeding the chickens. Children also often gathered the eggs. When the chickens were free to roam, they often laid eggs in nests in weeds, in other sheltered places or in buildings, even if they had nests in a henhouse. The children hunted the eggs. Once they found a nest, they would check it because the hens often returned to the same nest to lay more eggs. If a hen wanted to sit on her eggs, she would peck the person trying to collect the eggs. When children went barefoot in the summertime, chickens often pecked at their toes. How would you like to live on a farm where you fed the chickens and gathered the eggs? What would you do if the chickens pecked you?

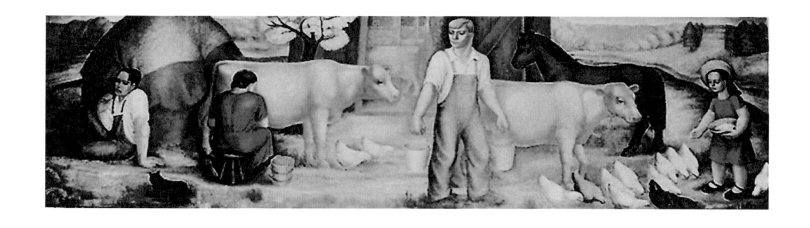

"Rural Scene - Wakarusa Valley,", Artist: Irene Bianucci, Date: 1941, Commission: $700
Post Office: Mount Carroll

Let's travel east to Sandwich, west of Chicago on US Route 34. In this post office we find a terra cotta relief of farm animals titled "Family." The mothers and children seen here are a mare and her foal, the ewe and her lambs and the sow and her shoat. For a long time, these animals were common to every farm. Horses were needed to do much of the farm work and to provide transportation. Sheep provided wool for clothing and meat to eat. Hogs provided meat to eat. Farmers invited neighbors to help butcher hogs during the cold of winter. Usually farm families ate the male animals because they wanted the females to raise more animals. Some of these animals were traded for other animals or for things that farm families needed. As money became more available, livestock was usually sold for cash. Sometimes animals were sold at an auction house, where people bid on the animals they wanted.

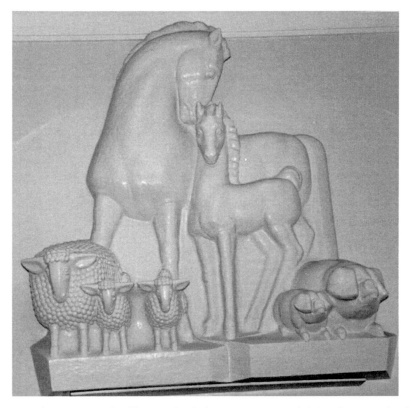

"Family," Artist: Marshall Fredericks, Date: 1941, Commission: $800
Post Office: Sandwich

27

We continue east on US Route 34 to Plano. The two wood reliefs in this post office show a farmer and his wife. Women cared for the garden and preserved the food. Poultry, such as chickens, was also their responsibilty. Sometimes women fed and milked the cows and fed the hogs, while the men cared for the horses and did the farmwork. Early farmers plowed, disked and harrowed the fields. Then they planted the seeds, cared for the plants, and harvested the crops. Women sometimes helped with the farming. Here we see a man and a woman harvesting corn in Illinois, one of the largest corn-producing states in the United States.

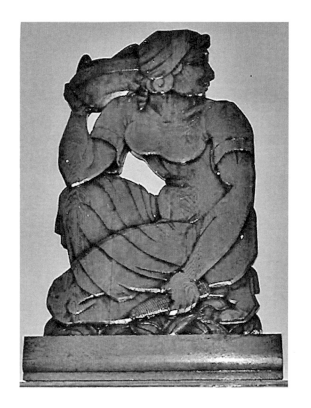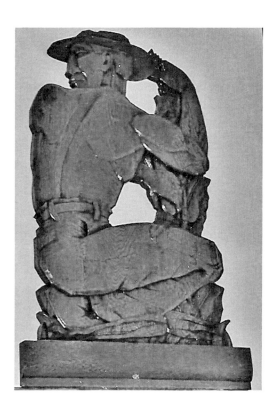

"Harvest," Artist: Peterpaul Ott, Date: 1941, Commission: $750
Post Office: Plano

29

If we continue east on US Route 34 to Illinois State Route 83 and go north, we will arrive at Elmhurst. When we look at Elmhurst today, it may be hard to imagine that this area was once mostly farmland. Early farmers didn't have the farm equipment that we have today to raise corn, wheat, oats, rye, and barley. In this post office mural we see men harvesting a crop, probably wheat. One man is cutting the wheat with a scythe. Another is tying the wheat into sheaves. The man on the left is loading it onto a wagon that is pulled by oxen. At one time oxen were used by many farmers to do the work in the field. We also see women, children, and a man watching the men work. Often the children were responsible for seeing that the men had water to drink. Wheat, oats, and rye were harvested during the hot summer months, so the farmers often really needed a drink. How would you feel about farming the way that farmers did then?

Before threshing machines were invented, farmers had threshing floors, where they beat the wheat heads to remove the grain. Then they had to winnow it to remove chaff and pieces of straw. When a breeze was blowing, they would scoop up the grain, hold it well above a container, and pour it slowly into the container. The breeze would blow the chaff, the husks that had covered the grain, away. All that was left was the grain.

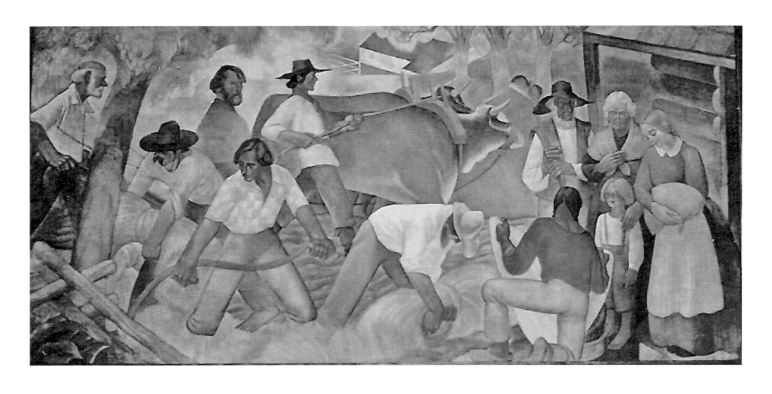

"There Was a Vision," Artist: George Melville Smith, Date: 1938, Commission: $630
Post Office: Elmhurst

From Elmhurst we go north of Chicago near Lake Michigan to the Wilmette Post Office. It is east of I-94 and US Route 41. Like Elmhurst, Wilmette was once mostly farmland. This mural is very different from other murals we have seen. In the semicircle in the center of the mural is corn with a barn in the background. Do you see other differences in this mural?

In the background on the left we see a barn and a silo. Barns were used to store grain and hay for the livestock and to provide shelter for them. We see men with a cow. Most farmers had cows because they were the source of milk and cream. After the cow was milked, the milk was poured through a cloth or a strainer into a crock to get rid of any dirt that had fallen into the bucket. When the milk was cooled, the cream would rise to the top and could be dipped off into a churn to make butter. Some of the milk would sour and turn to curds and whey. Then it was heated to make the curds into cheese. The whey was drained off and fed to the hogs.

On the right side of the mural we see men with one of those all-important animals, the horse. The title, "In the Soil Is Our Wealth," tells the story of farming. Most families lived on farms and depended on the produce from the farm to provide them with most of the things they needed.

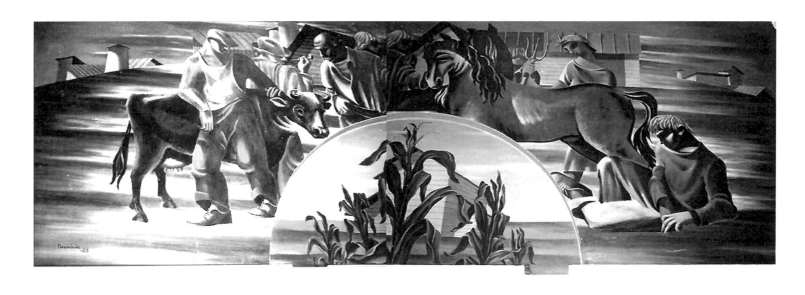

"In the Soil Is Our Wealth," Artist: Raymond Breinin, Date: 1938, Commission: $1,300
Post Office: Wilmette

33

From Wilmette we head to East Central Illinois to the post office in Marshall on I-70, US Route 40, and Illinois State Route 1. When we enter the post office, we see a mural showing a farmer, who has grown wheat. Wheat ripens in late June or early July. In the center men are gathering up the sheaves of wheat. On the left a farmer is riding a reaper that is pulled by horses and is cutting the wheat. With a reaper the men had to gather the wheat and tie it into sheaves as the man on the right is doing. On the right side in the back is a threshing machine that threshes the wheat. The first threshing machines were powered by steam engines. The men pulled the threshing machine onto the farm with the steam engine. Each machine had a pulley on it. A belt was placed on the pulleys to connect them. When the pulley on the steam engine was activated, it turned the pulley on the threshing machine, and the machine threshed the grain. After the invention of tractors, a tractor was used instead of the steam engine. It sent the grain into a bin and blew the straw out into a pile. The straw was put into stalls as bedding for the farm animals. Reapers were replaced by binders which tied the grain into sheaves. In the 1940s combines replaced binders and threshing machines. The first combines were pulled by tractors. Combines have changed a great deal from the first ones, but they are still used to harvest grain today.

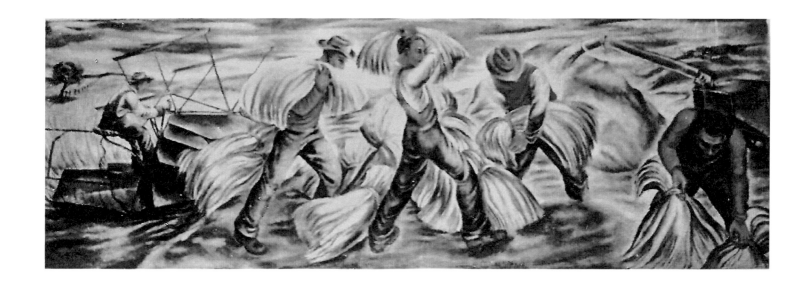

"Harvest," Artist: Miriam McKinnie, Date: 1938, Commission: $660
Post Office: Marshall

Let's head west to Gillespie, which is south of Springfield on Illinois State Routes 4 and 16. This mural depicts a farm family as they may have lived in the 1930s, when this mural was painted. Mail didn't arrive very often, so receiving mail was a big deal. In this scene the mail arrived early, because the mother has just finished milking and is carrying two buckets of milk. Cows were milked by hand early in the morning and late in the afternoon.

The chickens are looking for food wherever they can find it. They were fed corn and maybe mash, which is ground grain, but they still pecked around to see what they could find. Chickens provided farm families with eggs and, quite possibly, in the spring with baby chickens. Most of the roosters wound up on the dinner table as fried chicken, while some of the older hens might be killed and dressed for stewed chicken, chicken and dumplings, or were roasted with dressing, usually in the wintertime. The women were usually responsible for killing the chickens, either by cutting off their heads or by wringing their necks. The chickens then flopped around the yard for a while. When the chickens were dead, they were dipped in scalding hot water so their feathers could be plucked off. The insides were taken out and the chickens were cut into pieces. The pieces were usually cut so that the pulley bone, a y-shaped bone in the breast that was called a wishbone, was in one piece. After that meat was eaten, two single people usually pulled it to break it into two pieces. According to the story told, the one that got the shortest piece was supposed to get married first.

The gate to the barnyard was always closed so the livestock could not get out and wander down the road. This artist took the liberty of leaving the gate open for a better view of the cows. This family was fortunate to live so close to the town in the background. The daughter probably walked to and from school.

36

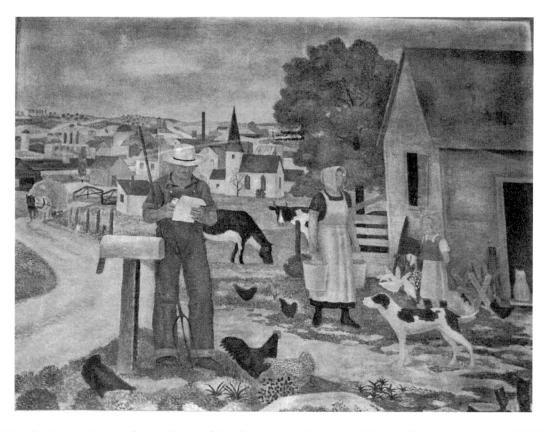

"Illinois Farm," Artist: Gustaf Dalstrom, Date: 1935, Commission: $320
Post Office: Gillespie

Now it's back east to Carmi. We find it on Illinois State Routes 1 and 14 south of I-64. In this post office mural we see another farm family that has just received its mail. The mail carrier is driving down the road. The mother is walking toward the house. She has lots of work to do. Besides taking care of the house and her family, she works in the garden and preserves food for the coming winter. The father is reading a letter before he goes back to work in the field, to take care of livestock, mend fences, or do any of the other jobs that need to be done. A barn is seen down over the hill. The haystack behind it is where the cows and horses can get to it. They eat the hay in the winter, while in warm weather the cows spend much of the day in the pasture eating grass as the horses do when they are not working.

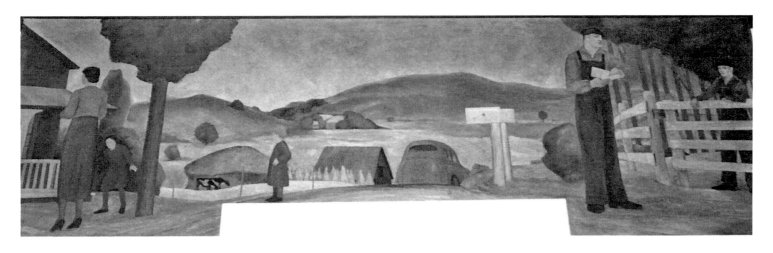

"Service to the Farmer," Artist: Davenport Griffen, Date: 1939, Commission: $700
Post Office: Carmi

39

From there we go back to the Decatur Post Office to see two more murals. This is the center mural of Mitchell Siporin's murals titled "Fusion of Agriculture and Industry." A farm family is standing in front of a corn blower. One of the sources of feed for cattle in the winter was silage. It was green corn cut into pieces and placed in a silo. The corn was cut and hauled by wagon to the corn blower, which cut it in little pieces and blew it into the silo.

We also see a hog that has been butchered. Many farmers raised more cattle and hogs than they could use. They sold them to be butchered and sold for food to people who didn't raise livestock. Two men shown here are handling grain. By the 1930s many farmers were raising more grain than they needed for their family and their livestock, so they sold it to be processed into flour, cereal or other products. As farmers grew more food to sell, factories were built to process food, and most farm families began buying flour and cereal in grocery stores.

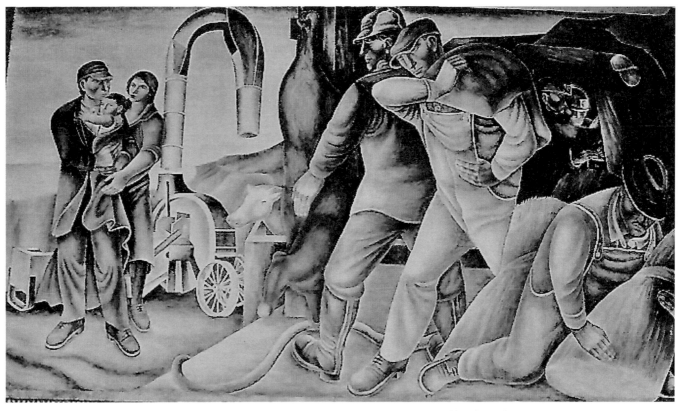

"Fusion of Agriculture and Industry," Artist: Mitchell Siporin, Date: 1938,
Commission: $2250 for three murals
Post Office: Decatur

While we are in the Decatur Post Office, we will look at Siporin's third mural. In the background we see a factory. Industry became important to the Decatur area after the arrival of the railroads. Many of the factories made farm equipment. The mural on the right shows factory workers building a cornpicker. They used overhead tracks with cables and hooks to move parts of the machinery into place so they could fasten them together. Before the invention of the cornpicker, farmers hitched a team of horses to a wagon and headed for the cornfield. They either picked the corn by hand or with a shucking peg that was strapped to their hand. With the peg they could pull the shucks back from the ear of corn, snap the ear off the plant, and throw the corn into the wagon. The horses were well trained and only moved down the cornrow when the farmer signaled them and stopped when he hollered whoa. It took a long time to shuck the corn, and sometimes farmers had to do it in the mud or when it was cold and snowing. The invention of cornpickers made harvesting corn much easier. This farmer has brought the workers some corn, probably sweet corn, that they could take home to their families for supper.

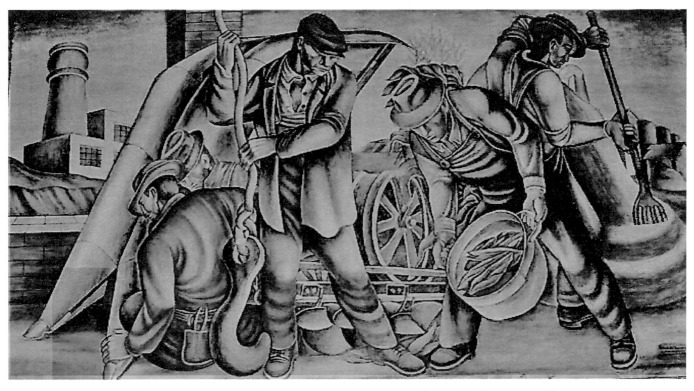

"Fusion of Agriculture and Industry," Artist: Mitchell Siporin, Date: 1938,
Commission: $2250 for three murals
Post Office: Decatur

43

Now let's go to Nashville, which is south of Decatur on State Route 127 south of I-64. In the mural in this post office we see a barnyard with chickens, turkeys, and ducks in front of the barn. These fowl often were free to roam the farm, but they stayed close to farm buildings because that was where they were fed. Most farmers included henhouses, where chickens and other fowl could be locked inside at night to protect them from wild animals like foxes, raccoons and opossums. Through the barn door we can see cows and horses. In the winter these animals spent much of their time in the barn or the barnyard. During the rest of the year they spent much of their time in a pasture. Beyond the animals is a threshing machine that was used to separate the wheat, oats, barley or rye from the straw and chaff.

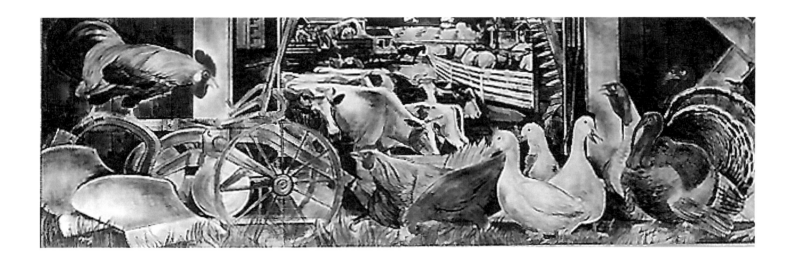

"Barnyard," Artist: Zoltan Sepeshy, Date: 1942, Commission: $750
Post Office: Nashville

From Nashville, we go north on Illinois State Route 127 to Carlyle. The Carlyle Post Office has three cast stone reliefs that show important means of farming in the area. The man with the fish represents the fish hatchery east of Carlyle that was operated by the state of Illinois from 1925 until about 1955, when it became a state park. Here they raised fish to be put into ponds in the area and lakes in state parks.

In the center is a barn with a silo. Barns were important to shelter cows and horses, and to store the feed for the livestock. Most barns had a haymow in the top to store hay and straw. The farmer would cut the hay and rake it into rows using horse drawn machines. After it dried, he would use a pitchfork to throw the hay onto a wagon to take it to the barn. There they had pulleys and a hayfork tied to a rope to pick up the hay and put it in the haymow. This was done with a horse pulling the rope. After tractors and hay balers were invented, men rode on the sides of the baler to tie the hay into bales with heavy cords or wire. Later the baler was improved to tie wires around the bales. Then men had to load the bales on a wagon, haul them to the barn, and unload them into the barn.

Next is a woman with a calf. The area had many dairy farms, which provided milk for the nearby towns. Carlyle was home to B & O Milk Company, which began operations in 1905. The B & O Company processed milk into condensed milk. At one time it could process 15,000 pounds of milk daily. Most of the condensed milk was shipped to Anson Dairy in St. Louis, with some going to a dairy in Centralia.

The dairy farmers raised most of their cows. When a cow had a calf, it often needed extra care. Sometimes they were taken to the house to keep them warm and were fed with a bottle.

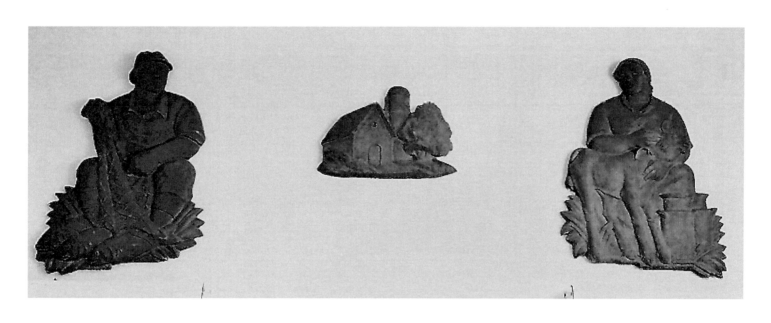

"Fish Hatchery," "Farm," "Dairy Farming," Artist: Curt Drewes, Date: 1939,
Commission: $790
Post Office: Carlyle

47

Our last stop is the Uptown Station on Broadway in Chicago, where we see a ceramic tile mural showing a farmer and a musician. One listing of post office art had the title, "Carl Sandburg." Sandburg was a native of Illinois and wrote poetry about Illinois and its people. The quote on the mural, "From the sun and the fruits of the black soil, poetry and song sprang," which is the real title for the mural, may be by him.

We see a farmer and a musician. The sun is shining. Cows are in the mural. Two fodder shocks (shocks of corn are called fodder when it has been cut and dried) are near the farmer. The musician may be planning to sing songs about the farmer and his farm.

Farming has always been hard work, but for most farmers the rewards have been worth the work. They would rather farm than do any other work. Farming has changed greatly due to the introduction of new farm machinery. Most small farms are gone. But for many farmers poetry and song are still there in "the sun and the fruits of the black soil."

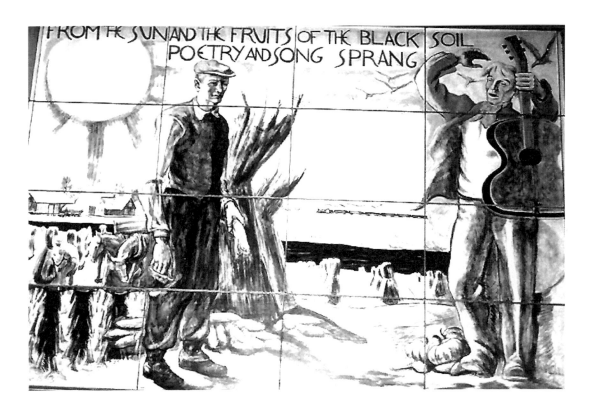

"From the Sun and the Fruits of the Black Soil, Poetry and Song Sprang,"
Artist: Henry Varnum Poor, Date: 1943, Commission: Unknown
Post Office: Uptown Station, Chicago

Post Office	Title	Artist	Page
Carlyle	"Fish Hatchery," "Farm," "Dairy Farming"	Curt Drewes	47
Carmi	"Service to the Farmer"	Davenport Griffen	39
Carthage	"Pioneers Tilling Soil and Building Log Cabin"	Karl Kelpe	11
Chicago Uptown Station	"Fron the Sun and the Fruits . . ."	Henry Varnum Poor	49
Decatur	"Early Pioneers"	Edward Millman	5
Decatur	"Early Pioneers"	Edward Millman	7
Decatur	"Fusion of Agriculture and Industry"	Mitchell Siporin	9
Decatur	"Fusion of Agriculture and Industry"	Mitchell Siporin	41
Decatur	"Fusion of Agriculture and Industry"	Mitchell Siporin	43
Elmhurst	"There Was a Vision"	George Melville Smith	31
Gillespie	"Illinois Farm"	Gustaf Dalstrom	37
Kankakee	"Farming"	Edouard Chassaing	23
Marshall	"Harvest"	Miriam McKinnie	35
Mount Carroll	"Rural Scene - Wakarusa Valley"	Irene Bianucci	25
Nashville	"Barnyard"	Zoltan Sepeshy	45

Post Office	Title	Artist	Page
Oak Park	"The Pioneer of 1848" and "The Osceola"	J. Theodore Johnson	15
Peoria	"Agriculture"	Freeman Schoolcraft	3
Plano	"Harvest"	Peterpaul Ott	29
Rock Falls	"Farming by Hand" and "Manufacture of Farm Implements"	Curt Drewes	21
Sandwich	"Family"	Marshall Fredericks	27
Shelbyville	"Shelby County Fair 1900"	Lucia Wiley	19
Tuscola	"The Old Days"	Edwin B. Johnson	17
Virden	"Illinois Pastoral"	James Daugherty	13
Wilmette	"In the Soil Is Our Wealth"	Raymond Breinin	33

Notes of Appreciation

The author wishes to express her appreciation to the following, who helped make this book a reality.

- Postal Service ™ artwork is published with the permission of the United States Postal Service. All rights reserved.

- Dorothy Harrison, Irene Homberger, Robert Sideman, Jacquelyn Cochonour, Diana Dragel, and Bobbi Harris, who reviewed my book and made recommendations to help make this book what it is.

- The members of Illinois State Organization of The Delta Kappa Gamma Society International for their financial support and encouragement as I work on this project.

- Tom Whitmore, sales representative for Gordon Bernard Company, LLC. for his interest and financial support for my book writing projects and to Gordon Bernard Company for doing such a professional printing job on my books.

Other materials available from the author

1. *A Guide to Depression Era Art in Illinois,* a book with clips of art and color-coded maps to encourage people to visit the post offices to see the art.

2. *Depression Era Art in Illinois Post Offices,* a video or DVD that tells about the four New Deal art projects with a focus on the art in the Decatur post office.

3. *Let's Look for Lincoln in Illinois Post Offices,* which tells about Lincoln's life in Illinois and is illustrated with post office murals related to Lincoln.

4. *Let's Look for Mail Delivery in Illinois Post Offices,* which gives the history of mail delivery and is illustrated with post office art.

5. Website: rrl.net/users.methomwi
 For more information, call 217/967/5362